Moments

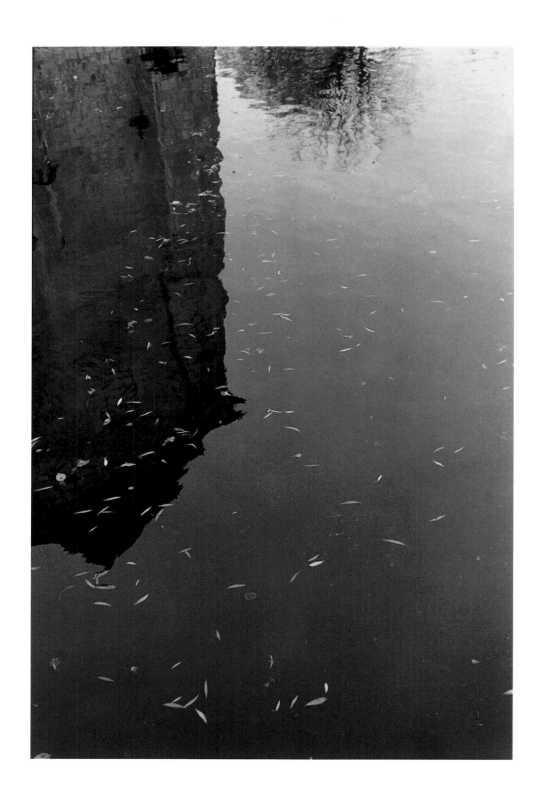

Moments

Photography by Claire Yaffa

Foreword by Gordon Parks

RUDER FINN PRESS

Copyright © 2004
Editorial Director: Susan Slack
Creative Director: Lisa Gabbay
Art Director: Salvatore Catania
Ruder Finn Design, New York

First published in the United States in 2004 by
Ruder Finn Press, Inc.
301 East Fifty-Seventh Street
New York, New York 10022

ISBN 1-932646-04-3

PRINTED IN THE UNITED STATES OF AMERICA
by Ruder Finn Printing Services, New York
Bryan D'Orazio, Senior Vice President
Alex Mezzo, Plant Manager
Steve Moss and Dave Harrington, Pre-Press

For my husband, children and grandchildren, with love.

Foreword

by Gordon Parks

Claire Yaffa's eyes have met many golden moments. Yet, in the course of an instant, certain ones keep springing into her existence that remain unforgettable—small and timeless ones that find a lasting place in her memory. An aged man walking up a gravel road, passes, greets her with a weary smile, coughs, then moves on—disappearing into a foggy horizon. It probably seemed unlikely to her that she would ever drink in this poignant moment again. But our planet, crammed with multitudes of moods, had made the moment possible. Surely she had not expected it—but thankfully she had captured it.

Imagery confronting Claire Yaffa can change quickly. Flowers, hungry for spring, lose their buds. Her camera's eye reaches out to acknowledge them. Tree limbs, once laden with golden leaves, go suddenly bare–swaying lazily in the frigid winds of early winter. She sways with them. Dawns arrive with brand-new skies and snowflakes fall differently. Her eyes lift to follow them. The moments spread. Deserted space closes in on a black night where a lamp's light spills through a distant window. A woman pushing a baby carriage crosses the street into oblivion. Portraits of lovely women emerge, garnished with exotic flowers.

She seems grateful to these images for having waited for her to embrace them, grateful for whatever brings them together. By moving so constantly from one to another, she appears to be rushing toward infinity. Time then seems to be exhaustible. But joy sings in the imagery that speaks to her, revealing the intimate moments she cherishes. They are whispers of her past that moved quietly, lingered for a few winged instants, then disappeared—leaving space for another precise moment to arrive, to pause while taking its place in time.

moments discovered
cherished
disappearing

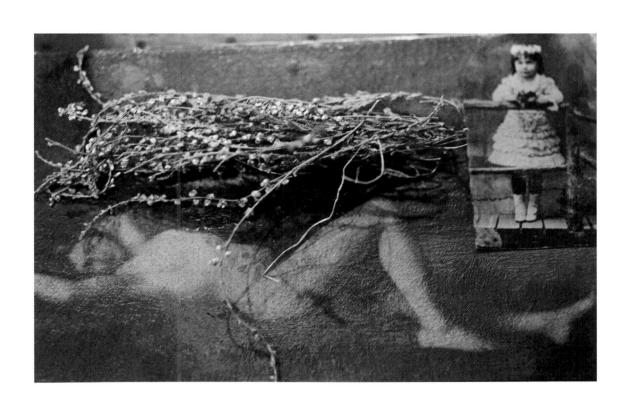

softly returning on a cloud

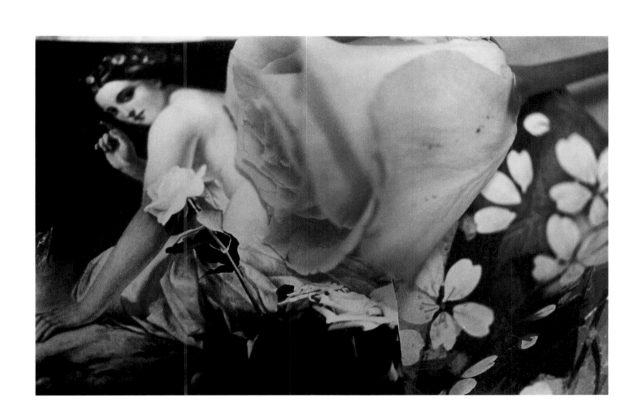

as whispers of the past become soundless memories

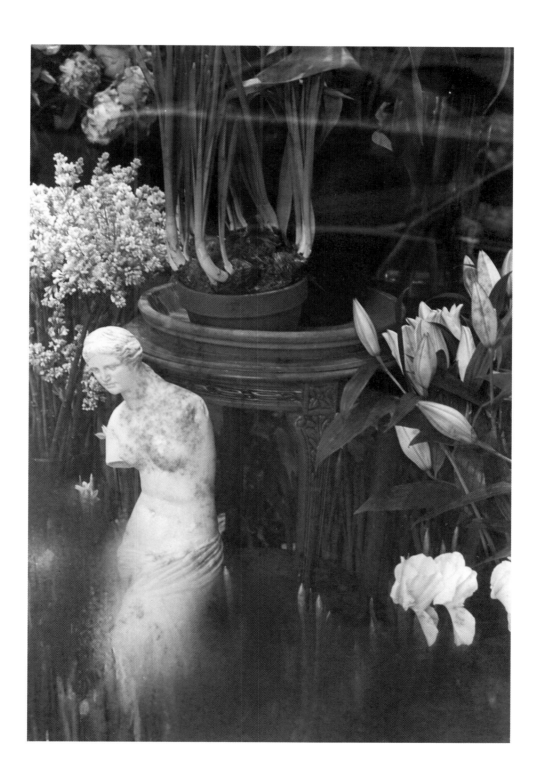

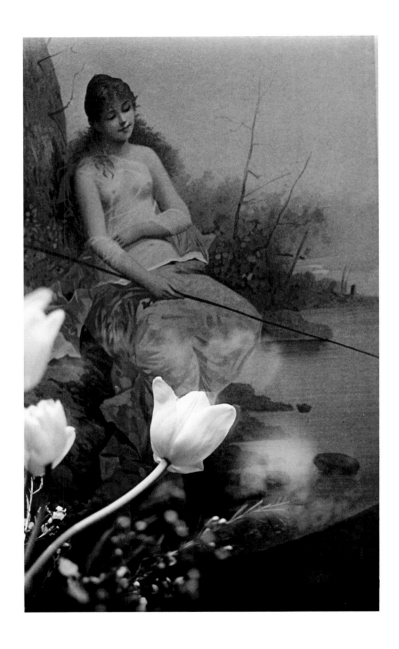

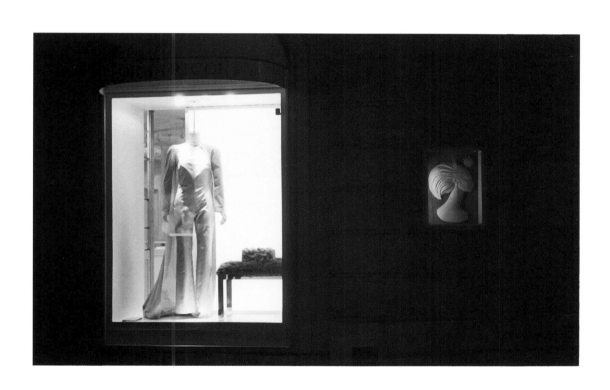

they were here
there
then gone

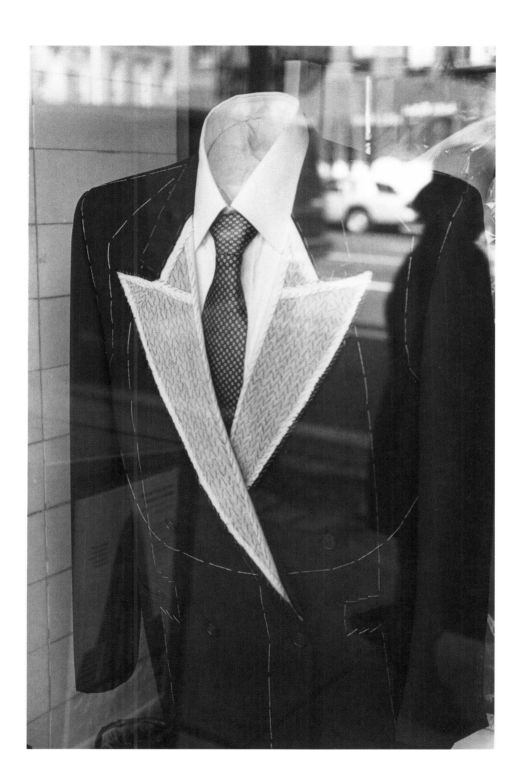

haunting tears floating into wells of nothingness

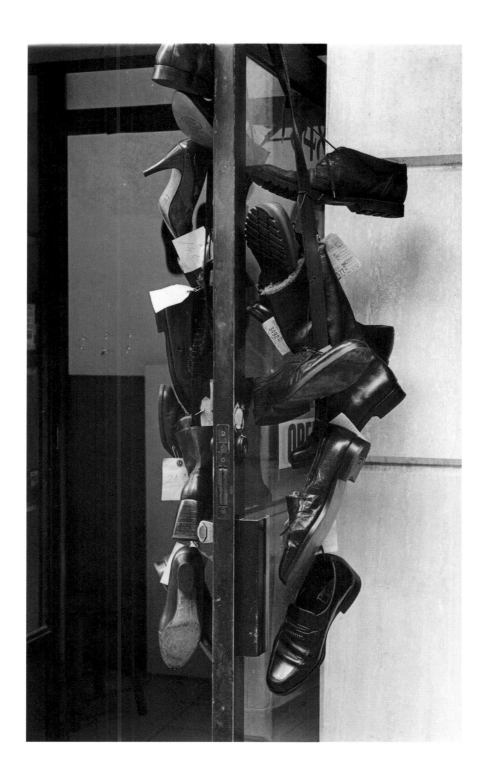

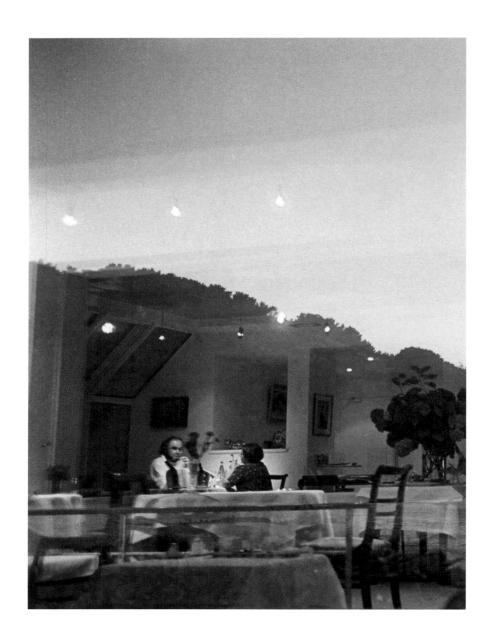

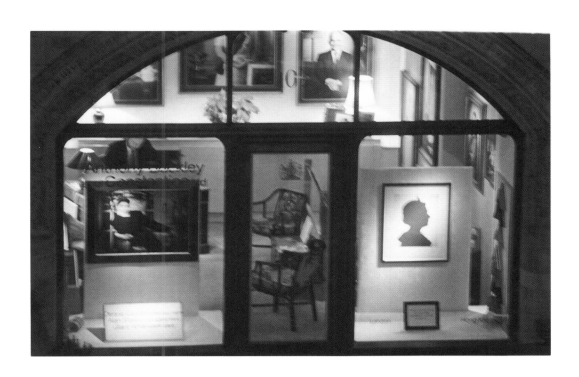

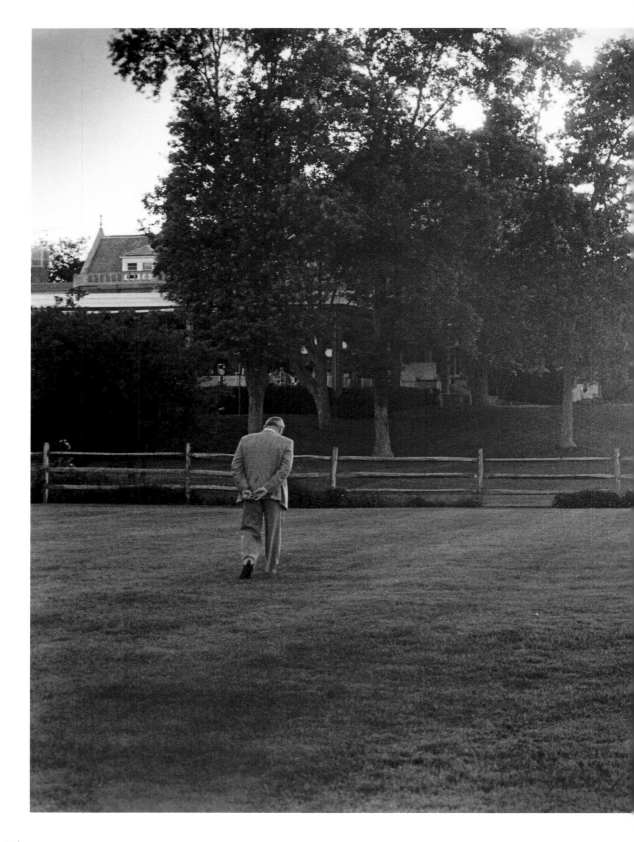

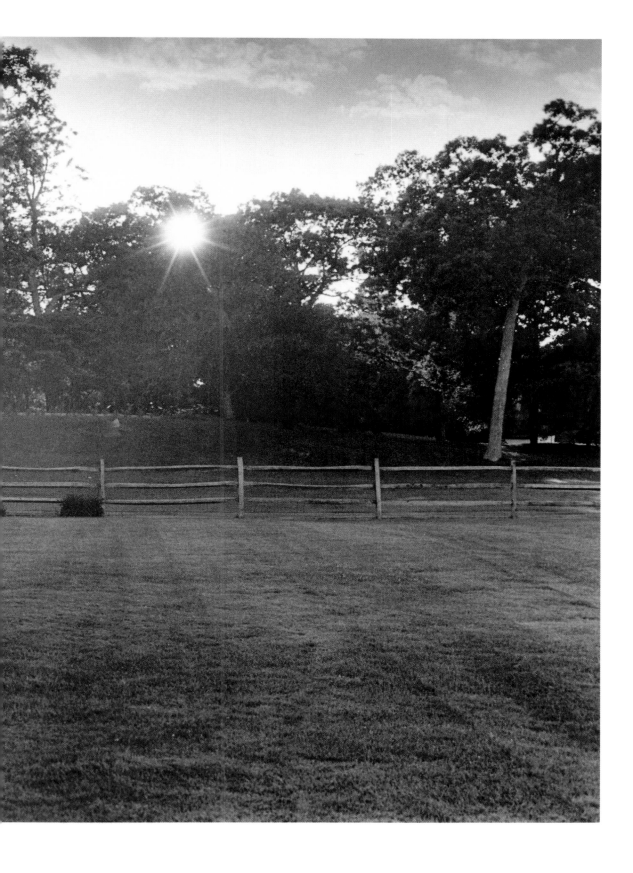

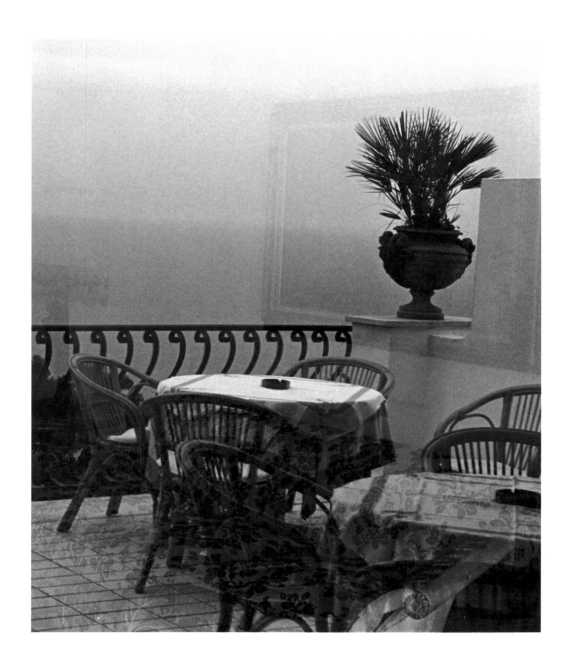

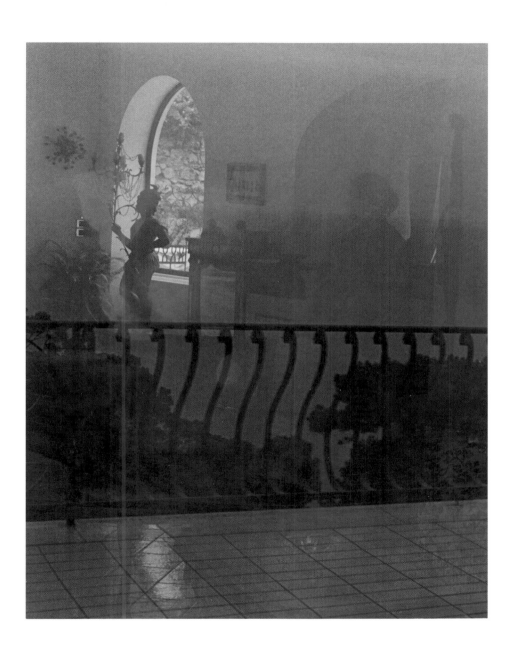

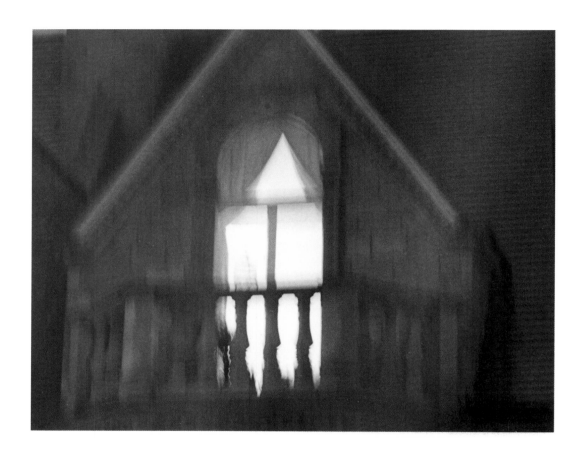

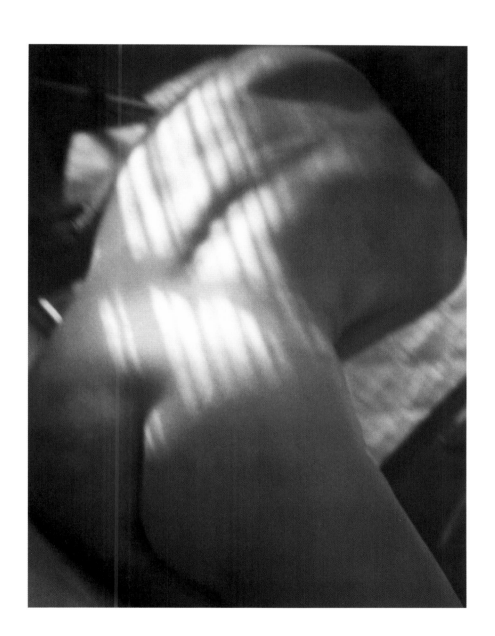

an instant becomes a memory

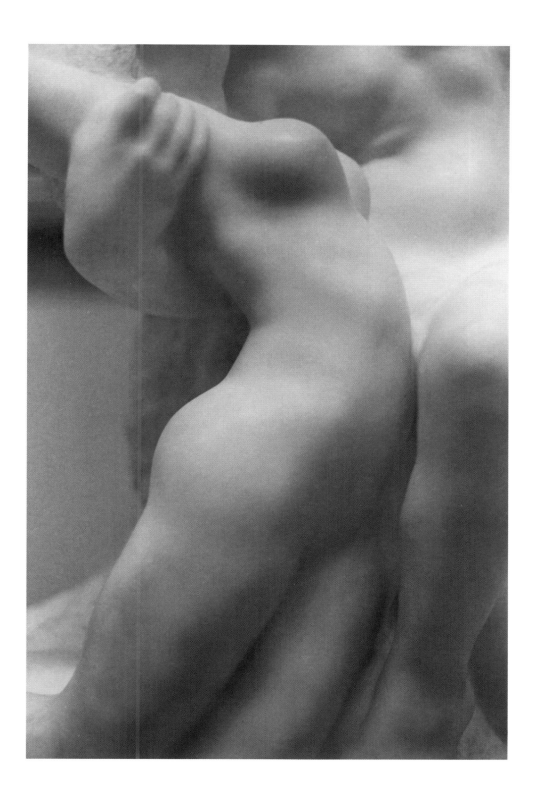

disappearing once again
a new life begins

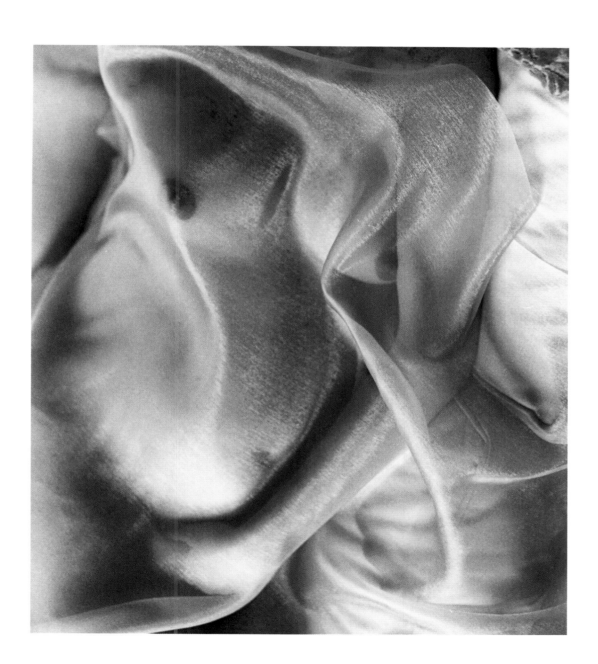

beyond hopes and dreams

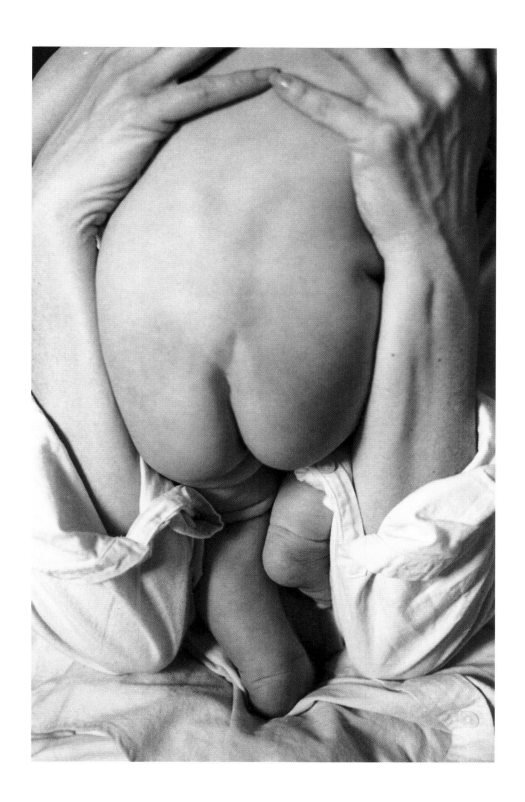

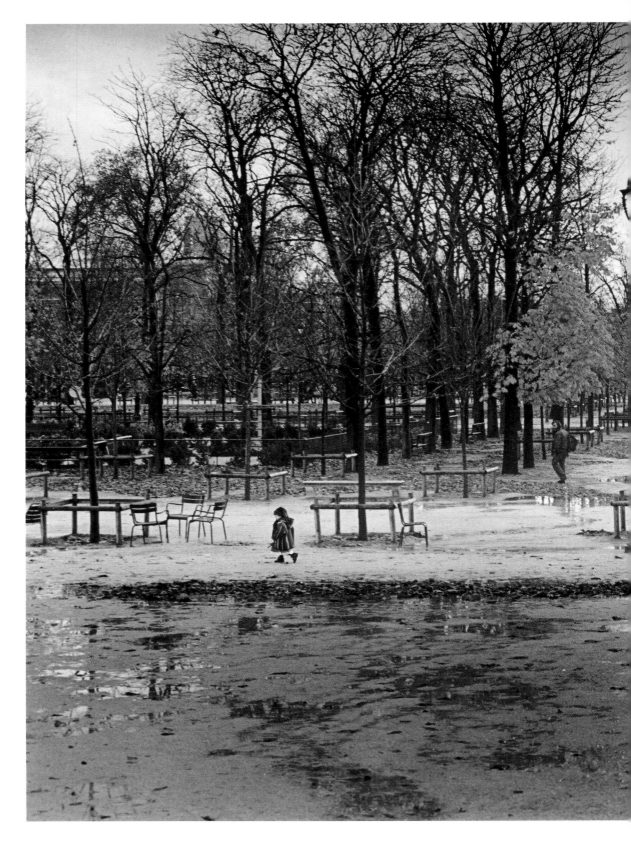

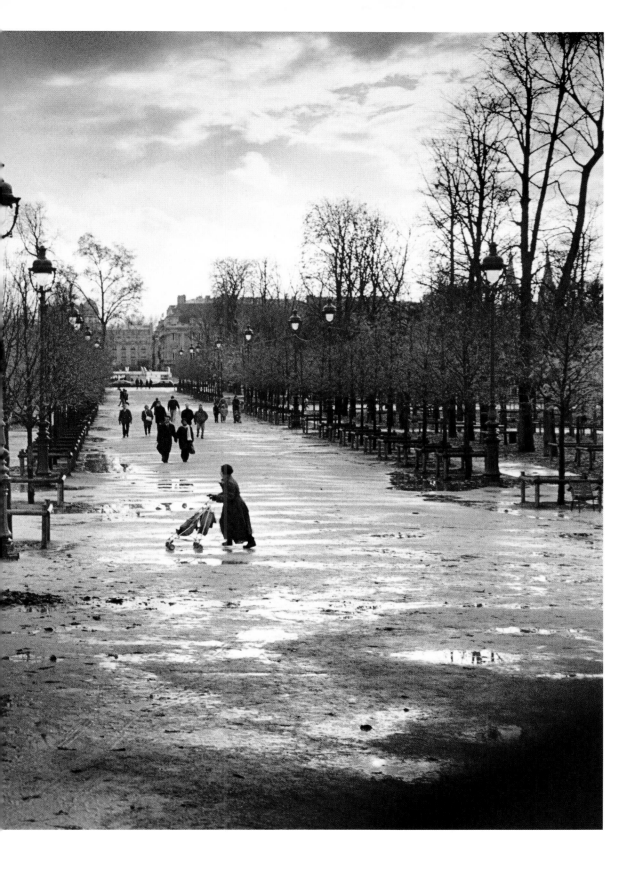

swept along with the events of time

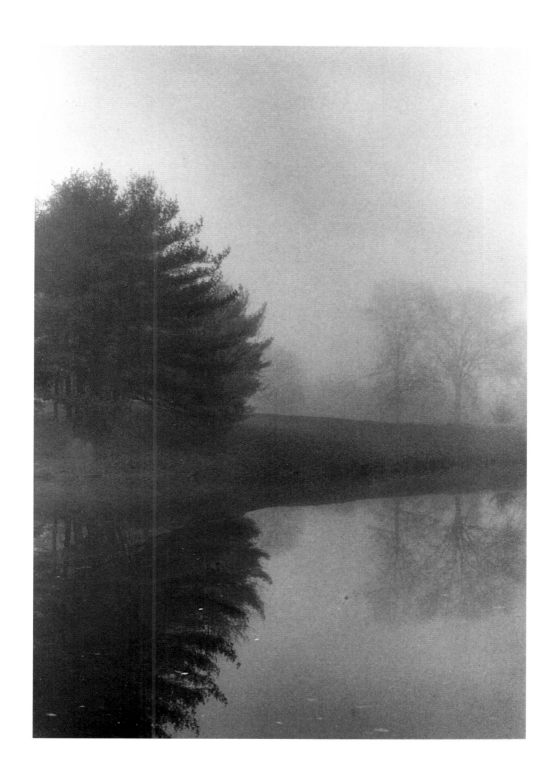

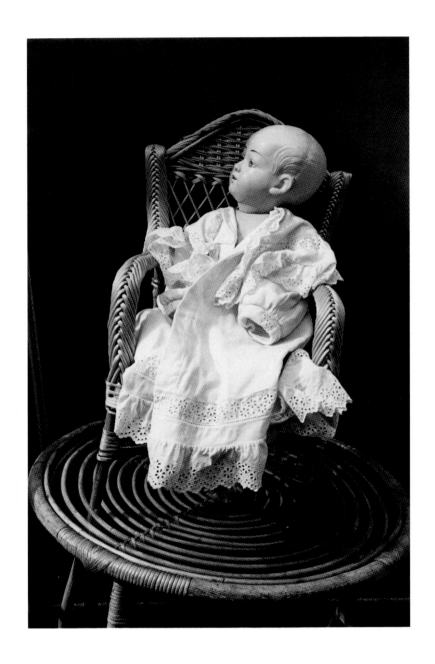

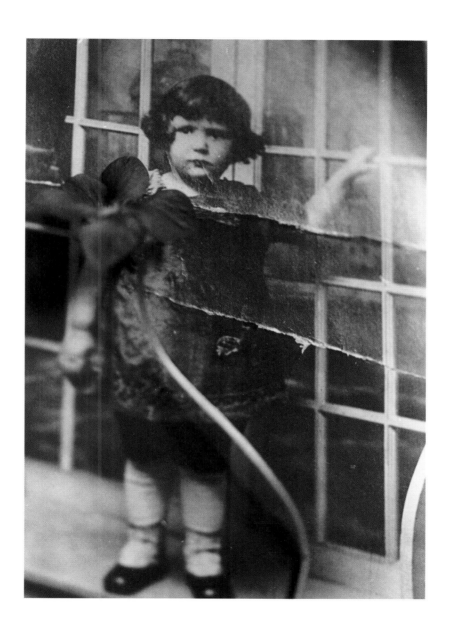

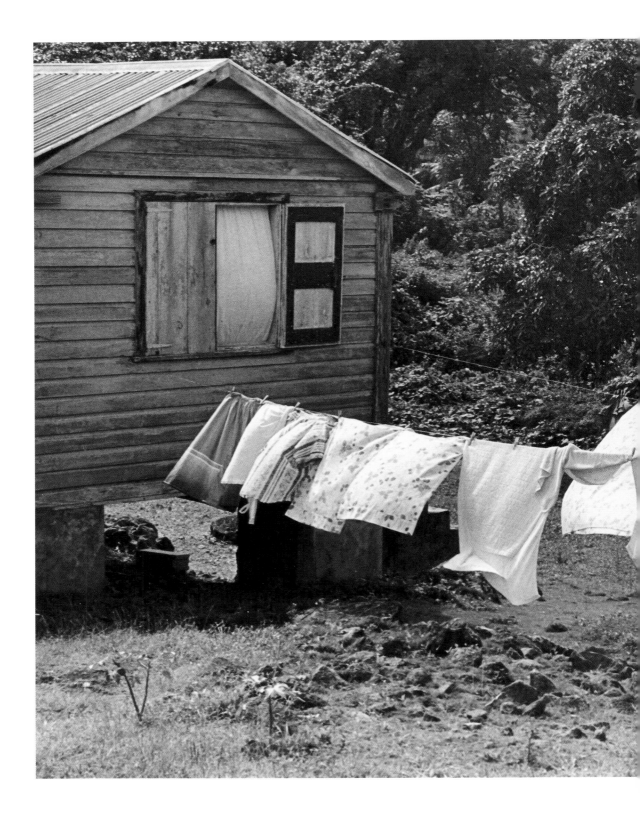

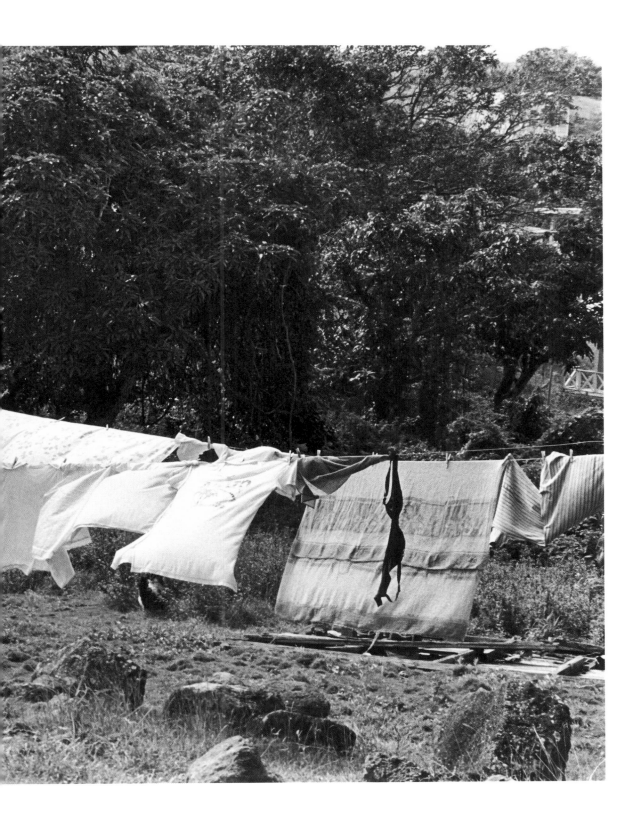

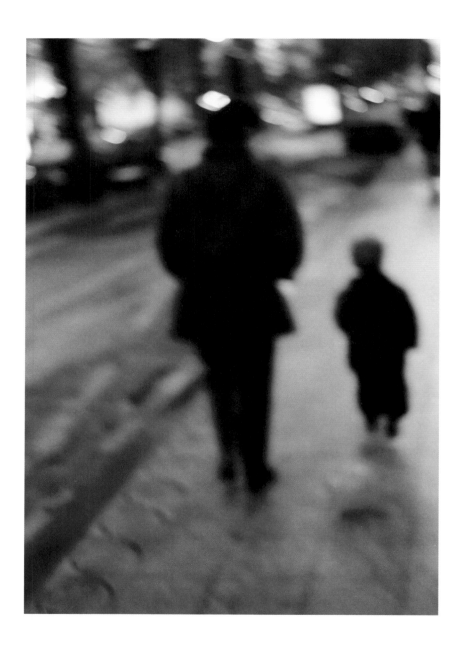

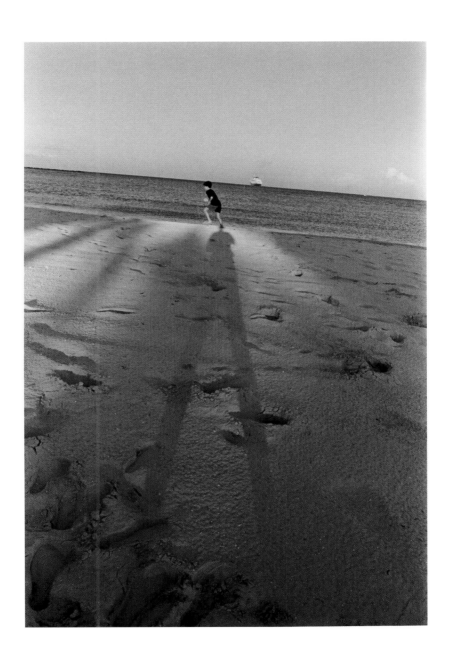

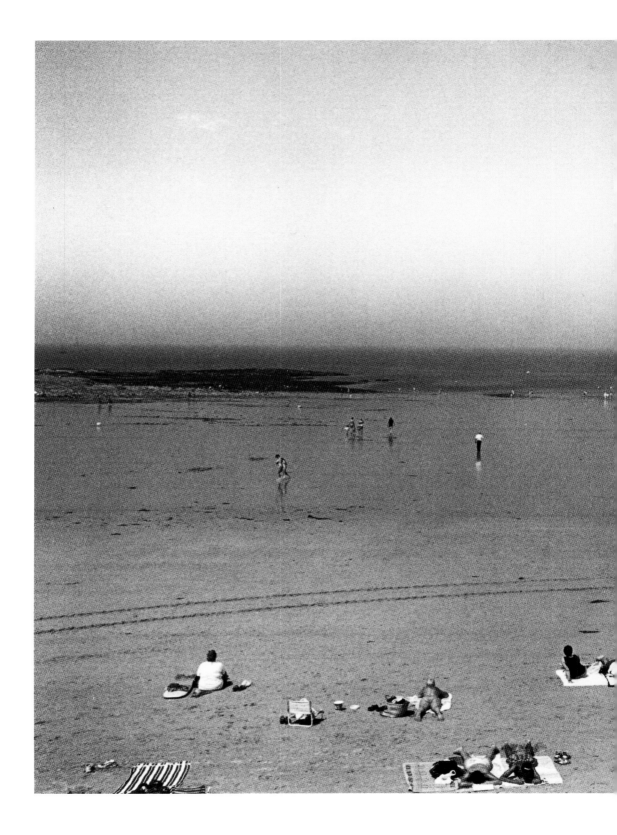

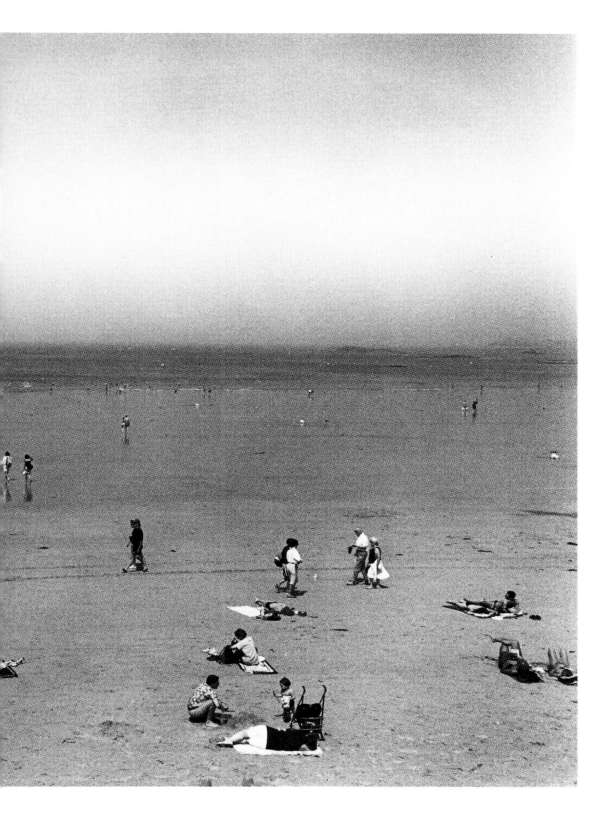

the past lies heavily on the present

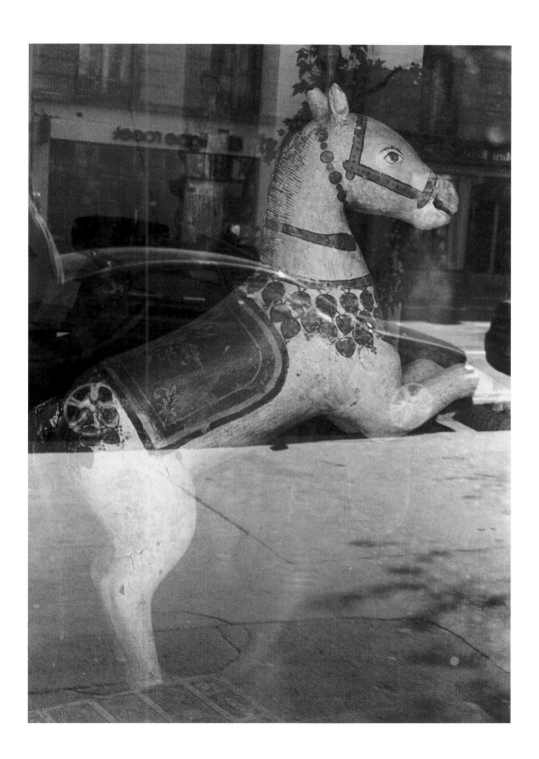

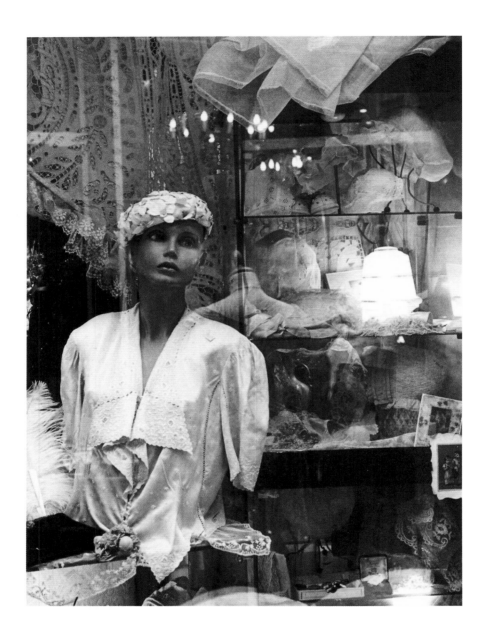

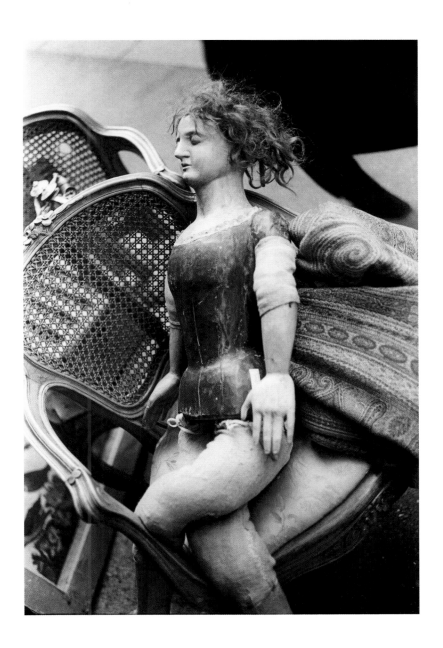

wondering if tomorrow will be there for you
for me

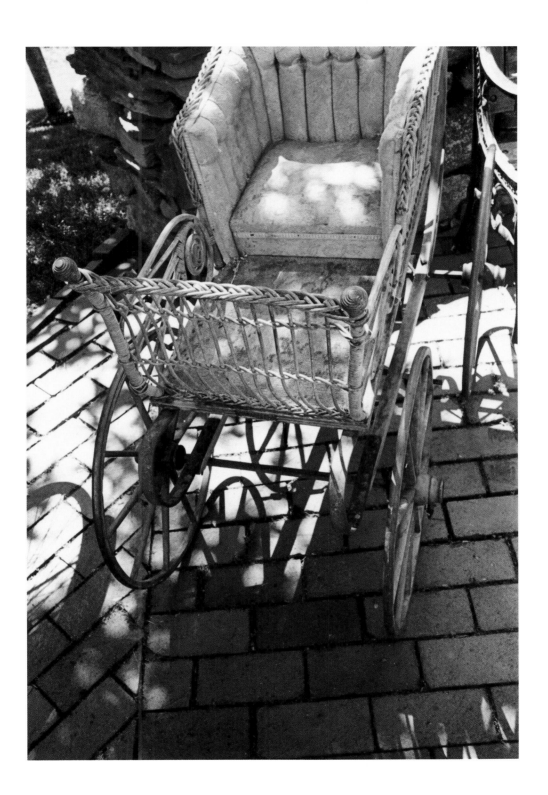

discovering it wouldn't last
I would have remembered it more

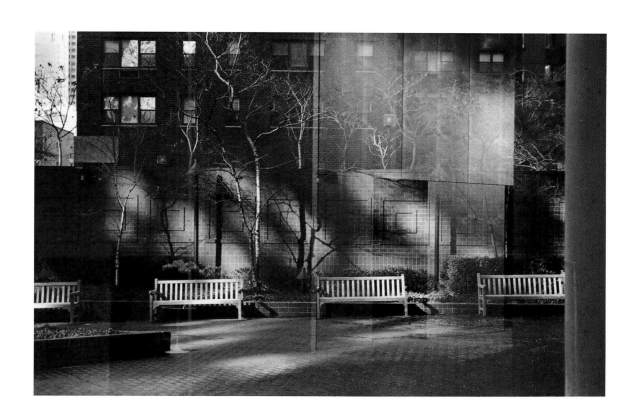

as the shadows of the past merge

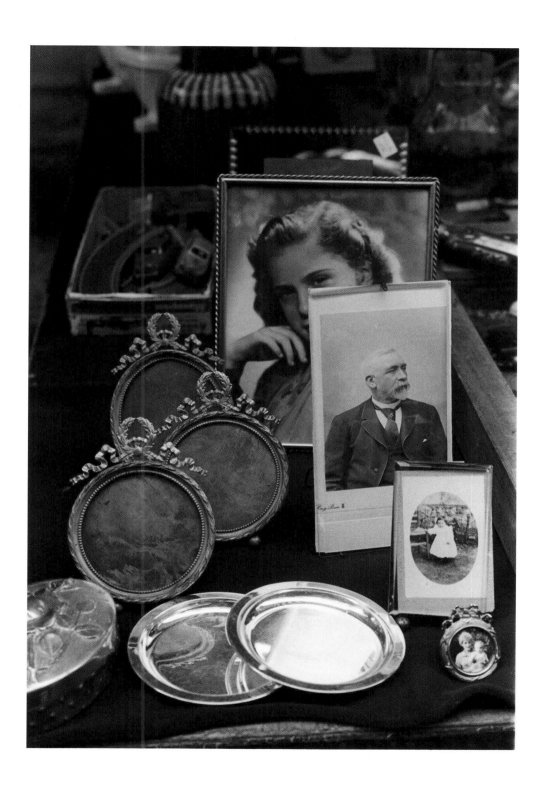

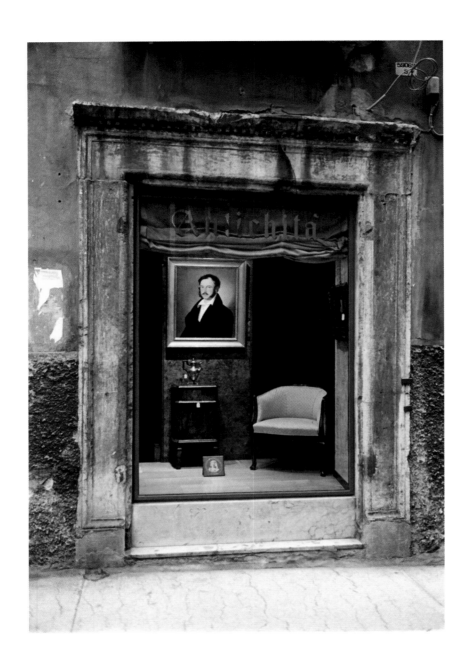

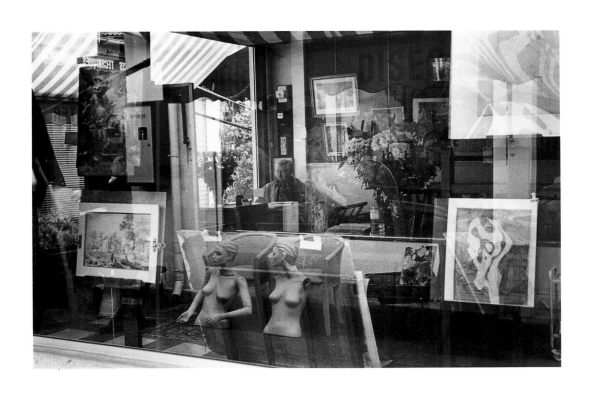

with the light of the future

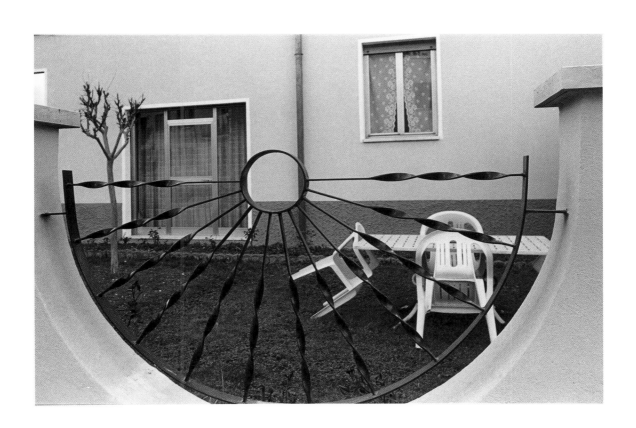

closed eyes hold on to the dream

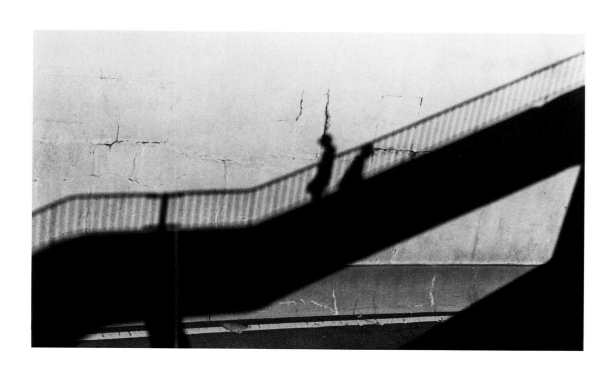

until a daylight moon appears

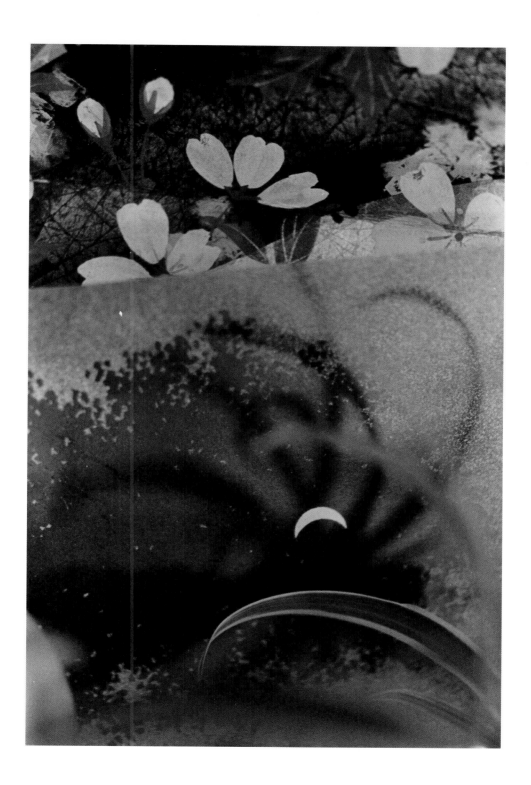

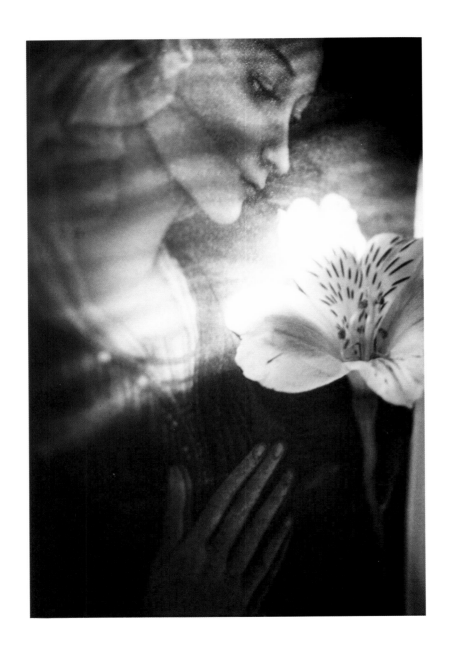

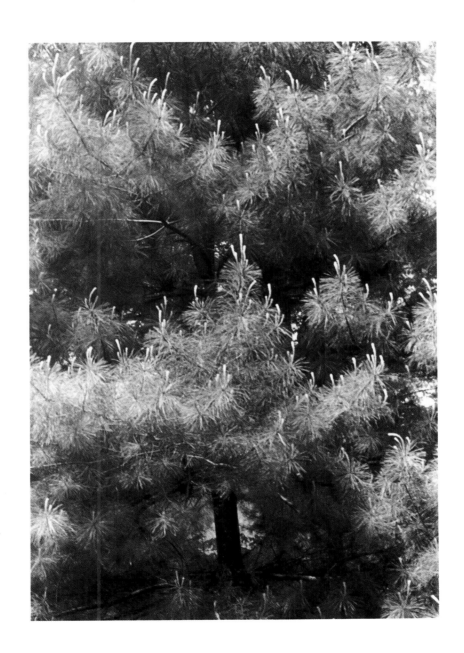

an ending becomes a beginning

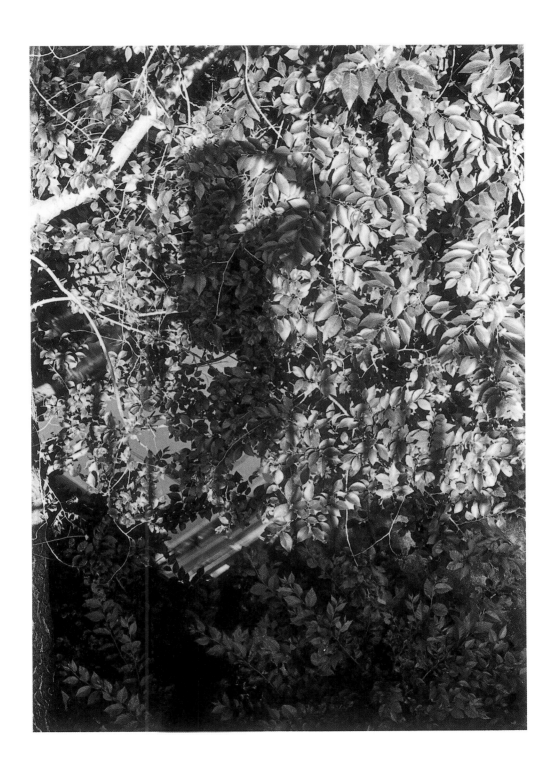

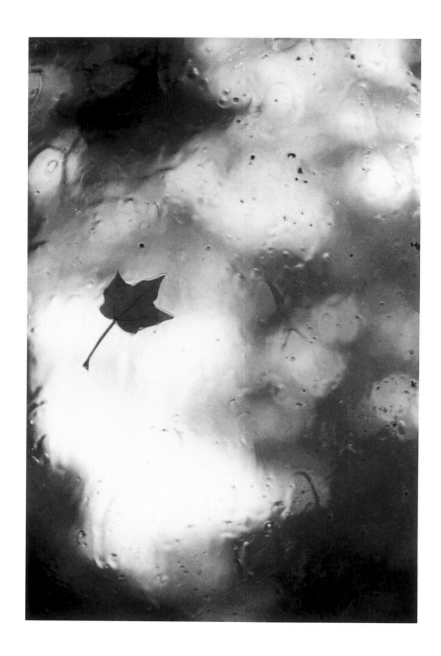

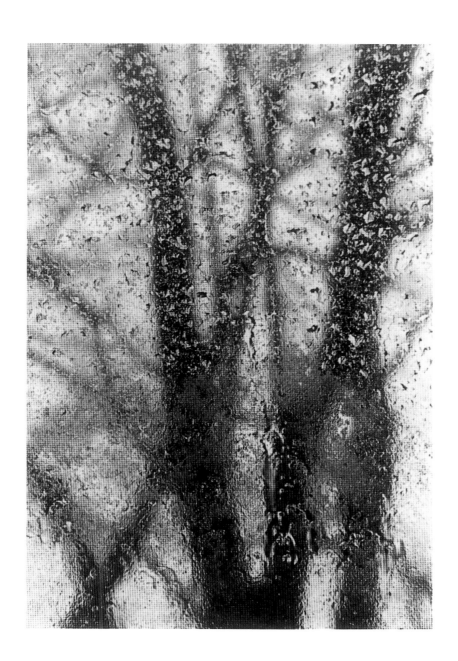

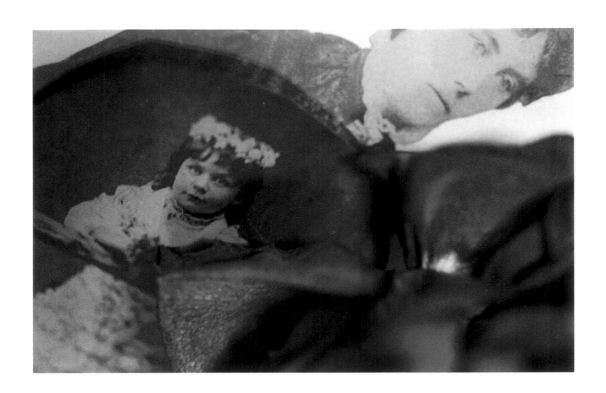

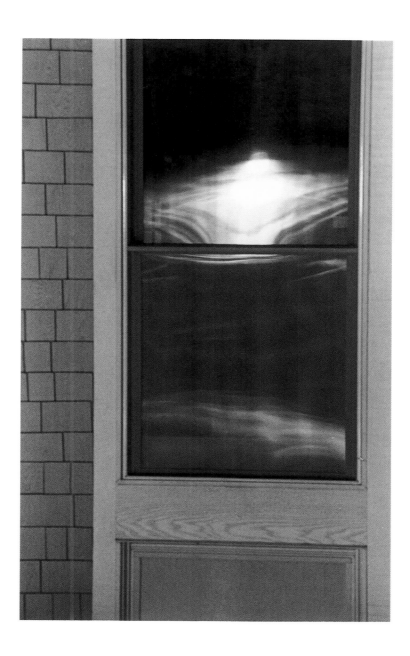

as a joyous moment comes again

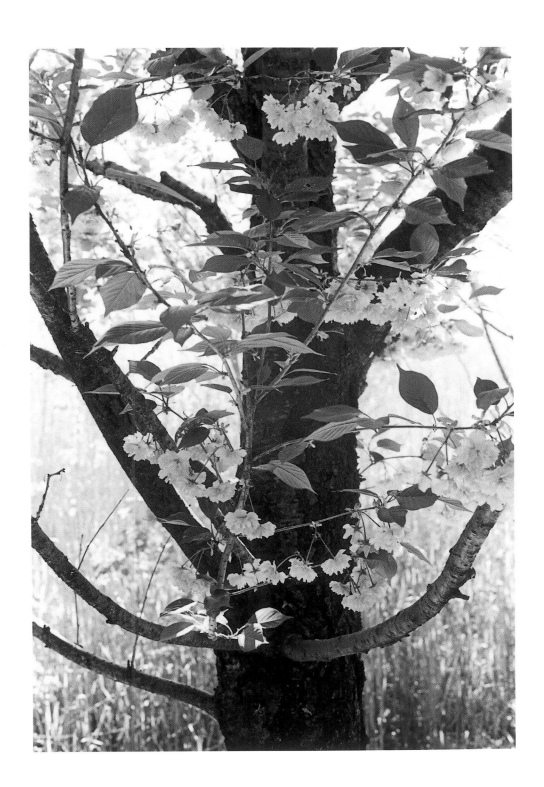

Moments

by Claire Yaffa

moments discovered
cherished
disappearing
softly returning on a cloud
as whispers of the past become soundless memories
they were here
there
then gone
haunting tears floating into wells of nothingness
an instant becomes a memory
disappearing once again
a new life begins
beyond hopes and dreams
swept along with the events of time
the past lies heavily on the present
wondering if tomorrow will be there for you
for me
discovering it wouldn't last
I would have remembered it more
as the shadows of the past merge
with the light of the future
closed eyes hold on to the dream
until a daylight moon appears
an ending becomes a beginning
as a joyous moment comes again

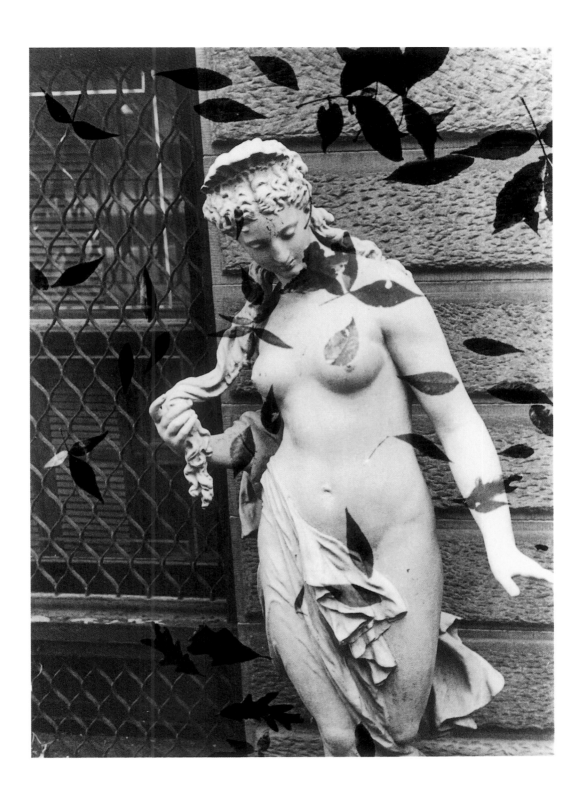

List of plates

Exhibitions

The Vincent J. Fontana Center
for the Prevention of Child Abuse
New York, NY
2005
Permanent Collection

Chelsea Art Museum, New York, NY
December 2003
Celebration of Women
Group exhibition [Publication, Assouline]

Fait et Cause, Paris, France
June 2002
*Life & Death Once Upon A Time: Children
with AIDS*

Simon Wiesenthal Center
@ Art Director's Club, New York, NY
1999
Who Will Remember?
Holocaust survivors, rescuers, hidden children

Office of the Westchester County Executive,
White Plains, NY
December 1998
Homeless children

Rye Art Center, Rye, NY
October 1998
Through The Lens
Juried exhibition of Westchester artists

International Center of Photography,
New York, NY
September 1998
Light and Shadow

Camera Obscura Gallery, Denver, CO
August 1998
Light and Shadow

Neuberger Museum, Harrison, NY
December 1996
Children with AIDS
Lecture and exhibition

Neuberger Museum, Harrison, NY
Summer 1996
*Harrison Mosaic: Portraits of Citizens Living in
Harrison, New York*
Lecture and exhibition

Cleveland Museum of Health and Science,
Cleveland, OH
June-August 1995
Children with Aids: An Endangered Species

Rockland Center for Holocaust Studies, Inc.
Spring Valley, NY
1994
Who Will Remember?

Sarah Lawrence College, Bronxville, NY
1993
Children With Aids: An Endangered Species

Camera Obscura Gallery, Denver, CO
1992
A Dying Child is Born: The Story of Tracy

Katonah Museum, Katonah, NY
1992
The Concerned Artist
Juried exhibition

The Bridge Gallery, White Plains, NY
1992
*Remembering Together: Photodocumentary
of Survivors Rescuers and Hidden Children
of the Holocaust*

The Bridge Gallery, White Plains, NY
1992
Making A Difference
Portraits of homeless children and
families at summer camp

Nardin Gallery, Katonah, NY
1992
Juried show

Hiram Halle Memorial Library, Pound Ridge,NY
1992
A Dying Child is Born: The Story of Tracy

Nikon House, New York, NY
1991
A Photographic Mosaic
Juried exhibition

Sarah Lawrence College, Bronxville, NY
1990
Discovery: A Continuing Journey

New York Foundling Hospital, New York, NY
1989 to present
Permanent collection, lobby

American Academy of Pediatrics, Chicago, IL
1989 to present
Portraits of Children
Permanent collection

The Bridge Gallery, White Plains, NY
1988
Homeless in Westchester County

The White Plains Museum Gallery, White Plains, NY
1988
Homeless in Westchester County

The International Center of Photography,
New York, NY
1987
Reaching Out
The problems of child abuse and rehabilitation

Sarah Lawrence College, Bronxville, NY
1987
Our World, Photographs of Children

Harrison Public Library, Harrison, NY
1982
The Story of A Life, Mrs. Mosher

The United Nations, New York, NY
1979
The International Year of The Child
Exhibition and poster

White Plains Museum Gallery, White Plains, NY
1979
The Child
For 'The International Year of the Child'

The Hudson River Museum, Yonkers, NY
1977
*The Blue Hammer: Portraits of Children at
LeakeWatts Children's Home*
One woman exhibition

Mexico
1975
International Year of the Woman Conference
Poster and invitation

Harrison Public Library, Harrison, NY
1972
Portraits of Children

Ms. Yaffa's photographs have appeared in *The New York Times, Food Patch, Woman's News, Vogue, The Wag, Vanity Fair, Daily News, Newsday, NBC News, ABC News.*

She was the recipient of the 1995 Council for The Arts Award for "Outstanding Artist in Westchester County."

Publications

LEICA: The Camera and Photographer
[Exhibition, book, calendar]
2005

Moments
Ruder Finn Press
2005

Embracing the Past:
"The Elders Speak"
2004
[On aging]

History of The New York
Foundling Hospital
2001

Light and Shadow
APERTURE
1998

A Dying Child is Born:
The Story of Tracy
1990

Reaching Out
[The problems of
child abuse and rehabilitation]
1987

Homeless in Westchester County
1988

Biography

B.A. Sarah Lawrence College
1962

Research Technician
Memorial Sloan Kettering Hospital
1959-1966

Emergency Medical Technician and
one of the founders of the
Harrison Volunteer Ambulance Corps
1983-1988

Photographic studies with:
Fred Picker, Lisette Model, Phillipe Halsman,
W. Eugene Smith, George Tice, Eva Rubinstein,
Joseph Schneider, Sean Kernan, Ralph Gibson,
Duane Michals, Cornell Capa, Gordon Parks

Photo Editor
Westchester Magazine
1977- 1987

Chairperson
Breadth of Vision, Fashion Institute of
Technology, NY
1975
[Largest juried exhibition of women's
photography in the United States]

Photography Coordinator
United Nations, NY
The International Woman's Arts Festival
1974